Erin
the Phoenix
Fairy

For Erin and Megan Hale,
with lots of love and fairy magic

Special thanks to Sue Mongredien

No part of this work may be reproduced, stored in a retrieval system, or transmitted in any form or by any means, electronic, mechanical, photocopying, recording, or otherwise, without written permission of the publisher. For information regarding permission, write to Rainbow Magic Limited c/o HIT Entertainment, 830 South Greenville Avenue, Allen, TX 75002-3320.

ISBN 978-0-545-38419-3

Previously published as Magical Animal Fairies #3:
Erin the Firebird Fairy by Orchard U.K. in 2009.

All rights reserved. Published by Scholastic Inc., 557 Broadway, New York, NY 10012, by arrangement with Rainbow Magic Limited.

12 11 10 9 8 7 6 5 4 3 2 1 12 13 14 15 16 17/0

Printed in the U.S.A. 40

This edition first printing, March 2012

Erin
the Phoenix
Fairy

by Daisy Meadows

SCHOLASTIC INC.

New York Toronto London Auckland
Sydney Mexico City New Delhi Hong Kong

There are seven special animals,
Who live in Fairyland.
They use their magic powers
To help others where they can.

A dragon, black cat, phoenix,
A seahorse, and snow swan, too,
A unicorn and ice bear—
I know just what to do.

I'll lock them in my castle
And never let them out.
The world will turn more miserable,
Of that, I have no doubt!

Contents

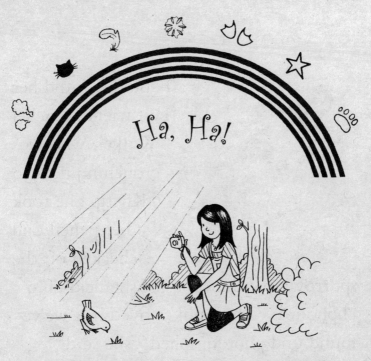

Ha, Ha!

Kirsty Tate held her breath, trying to keep her fingers steady on the camera. A little brown sparrow stood only a few steps away, pecking at something on the ground. The bird was crouched at the edge of a forest clearing, framed by leafy trees and bushes, with sunlight shining through. Kirsty pressed the button on top of the camera. *Click!* There—perfect.

"Fabulous," said her best friend, Rachel Walker, who was crouching next to Kirsty. She took her pencil and checked off the sparrow's picture on a list she held on a clipboard. "That makes five birds we've found and photographed," she said, feeling good. "The sparrow, thrush, blackbird, robin, and magpie. We just need the chickadee now, and we're done."

The two girls were spending a week of their spring break at an outdoor adventure camp. Today was Nature Day! All the campers had been put in pairs and given a list of plants,

animals, or insects to track down and
photograph. At the end of the day,
they were going to gather around the
campfire and share their discoveries
with everyone.

Rachel and Kirsty sat down on a
fallen log to look at the birdwatcher's
guidebook they had been given. Rachel
flipped through until she found a page
about the chickadee. "Here we are," she
said, looking at the photograph. "So,
it has a black head and throat, a short
bill, and a snowy white chest. Well, that
should be easy enough to spot."

"It says here that the chickadee is
acrobatic and clever, and has a funny
call: *chickadee, dee, dee,*" Kirsty said,
reading aloud. She tilted her head to
one side, listening hard. "I can't hear

anything like that," she said after a moment.

"I'll take a look with these," Rachel said, picking up their binoculars and scanning the glade. She moved them around slowly, spotting clumps of primroses and nodding daffodils, but no chickadees. The only bird she could see was a robin perched on a tree stump. Rachel giggled to herself as a joke suddenly popped into her head.

"What's so funny?" Kirsty wanted to know.

"I just thought of a joke," Rachel said. "Which bird steals from the rich to give to the poor?"

"I don't know," Kirsty replied.

"Robin Hood!" Rachel giggled.

Kirsty smiled. "I like that," she said. "I've got one, too. Which bird tells the best jokes?"

Rachel shrugged. "I give up," she answered.

"A comedi-HEN!" Kirsty replied. Both girls laughed.

"My turn," Rachel said. "Why does a hummingbird hum?"

"I don't know," Kirsty said.

"Because it forgot the words of the song!" Rachel cried, bursting out laughing. Kirsty, too, was helpless with laughter for a few minutes.

Kirsty recovered after a while and wiped her eyes. Then she caught sight of something unusual up in the tree tops. "Hey—what's orange, red, and yellow, and perches on a branch?"

"I don't know," giggled Rachel, thinking it was another joke. "What *is*

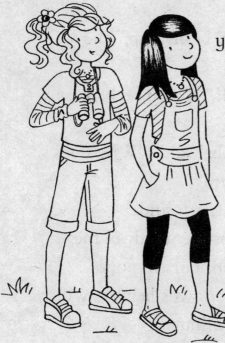

orange, red, and yellow, and perches on a branch?"

"No, no," Kirsty said. "I mean it. There's a bird up there, and it's the most beautiful creature I've ever seen. Look!" Rachel peered up with her

binoculars. She blinked in surprise as
the bird came into view. It was as big
as a parrot, with a long, trailing plume
of orange, red, and yellow feathers that
shined brightly in the sunlight, almost
like fire. "Wow," she said with a gasp.
"What *is* it?"

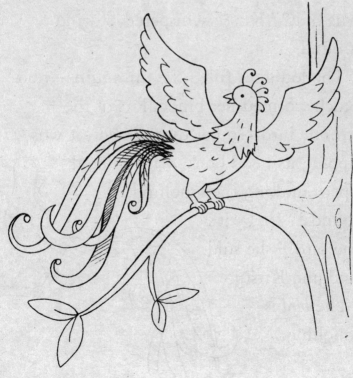

Kirsty began leafing through the guidebook to see if she could find a picture that matched the unusual bird. The pages included nothing like it!

Then the girls were startled by a sudden bright burst of laughter. Somehow, it didn't sound human. "What was that?" Kirsty whispered, staring around.

The laughter filled the air again—and Rachel aimed her binoculars at the strange bird. To her amazement, it was tipping its head back, with its beak open, making the laughing sounds! "It . . . it's the bird!" she said, nudging Kirsty. "The *bird* is laughing.

It must be magic!"

Kirsty's mouth fell open in delight as she realized something. "Yes—you're right," she said, smiling. "I bet it's the magic phoenix from Fairyland!"

Follow that Phoenix!

Rachel nodded. "Of course," she agreed, feeling a prickle of excitement. "The missing phoenix—right here in front of us!"

Nobody else at the outdoor adventure camp knew, but Rachel and Kirsty had a secret task to complete that week. They were helping the fairies track down the seven missing magical animals! Jack

Frost had stolen the animals, but they had all escaped from his Ice Castle and found their way into the human world.

The magical animals were important to the fairies, because they helped spread some very special qualities around the fairy and human worlds—qualities such as imagination, luck, humor, and friendship. However, since the animals were so young, they weren't in full control of their powers yet. The Magical Animal Fairies needed to find their animals and take them safely back to Fairyland before they caused any trouble . . . but this hadn't been easy so far. Jack Frost had sent his goblins to track down the magical animals, too. He didn't want humans or fairies to enjoy their unique gifts. Instead, he

wanted everyone to be as miserable as he was! "I just realized," Rachel said, as they gazed up at the amazing creature. "The phoenix's magical gift is humor, isn't it? That's why we've been telling jokes and laughing so much. Just being near the bird is doubling our sense of humor!"

"Oh, yes," Kirsty said. "I bet you're right. Well, we need to catch him and return him to Fairyland before any goblins show up and spot him. That way, the joke will definitely be on them!"

"Let's think of a plan,"
Rachel said. Just as she
spoke, the phoenix took off
in a glorious flash of color.
It was a breathtaking sight!
The creature flapped
his vibrant wings,
and the brilliant
shades shimmered
in the sunshine.

"Quick, let's follow
him," Kirsty said,
jumping to her feet and running through
the trees.

Luckily, the phoenix's extraordinary
feathers made him easy to see, but he
was fast, and the girls had to race to
keep up. Running while gazing up
at the sky was tricky! Rachel almost

tripped over some long tree roots that were sticking out of the ground.

After a few minutes, the bird landed on a rock at the other side of a shallow stream. He folded his wings, staring around with bright eyes. The girls didn't dare get too close in case they scared him away, so they sat down on the grassy bank of the stream and talked in quiet voices.

"Maybe we could lure him over here with some food," Kirsty said thoughtfully. "But what do phoenixes like to eat?"

"Scottsdales," Rachel joked, as she broke out in laughter. "Get it? Phoenix and Scottsdale are both cities in Arizona," she explained between giggles.

Kirsty smiled, too, but then shook her head. "No—we have to be serious. We'll never think of a plan if we keep making each other laugh."

Rachel nodded. "Yes, you're right," she said. "Maybe . . ." Then she stopped because she felt a strange tingling sensation in her pocket, where she had stuffed the birdwatchers' guidebook. She quickly pulled it out . . . and saw that a page in the middle was glowing with

a golden light. This definitely looked
like fairy magic!

Heart thumping, she flipped quickly to
the glowing page and opened the book.
She held it out so both she and Kirsty
could see. It showed a picture of a very
pretty fairy with wavy auburn hair. She
wore an orangey-red dress and sandals,
and had a flower tucked in her hair.

"*Fun Facts about Erin the Phoenix Fairy,*"
Rachel read aloud.

Kirsty huddled closer to read. "Oh, wow," she said, laughing as she saw the list of facts about Erin:

1. She likes making people laugh.
2. She doesn't like it when Jack Frost and his goblins steal things from Fairyland.
3. Her favorite thing in the world is training phoenixes to help spread humor throughout the human and fairy worlds!

"Oh, look, there's a joke," Rachel said, pointing to the bottom of the page. "Knock, knock."

"Who's there?" asked Kirsty.

"Fairy," said Rachel.

"Fairy who?" asked Kirsty.

Rachel was just about to point out that no punchline had been printed, when

they both heard a tinkling laugh. Then a tiny voice finished the joke: "Fairy pleased to meet you!"

A jet of sparkles jumped off the page . . . and Erin appeared right in front of their eyes!

A Close Call

Erin fluttered her sparkly wings and grinned. "Hello!" she said in her tiny voice. "How nice to see you again. Tell me, do you know what gets bigger the more you take away from it?"

"I don't know," Rachel replied with a smile. "What *does* get bigger the more you take away from it?"

"A hole!" Erin replied, clapping her hands together.

Kirsty and Rachel didn't laugh. They both understood the joke, but for some reason, they didn't find it very funny.

Erin's smile turned to a frown. "Ahh," she said. "I think Giggles the phoenix must be nearby. He's very clever, but he hasn't finished his training. Sometimes, by accident, he zaps the humor *out* of a joke instead of putting it *in*."

"Giggles *is* nearby," Kirsty told her. "Look—he's just over there on the rock." She pointed to where the phoenix was perched behind the fairy's back, and Erin immediately spun around.

A wide grin crossed her face and she

opened her mouth to call to him. But at
that very moment, two boys from the
camp rushed out from the bushes. Erin
had to dart quickly out of sight behind
a tree, and Giggles flew away from the
noise, high up into the treetops.

"Hi, Tommy. Hi, Jason," Kirsty said, recognizing the boys. "What are you up to?"

"We're trying to find all the butterflies on our list," dark-haired Tommy

replied as he held up a clipboard and guidebook. "We were hiding behind the bushes when we spotted a golden butterfly fluttering around you two."

"We think it's a clouded sulpher, which is the last one on our list," Jason added, pushing his glasses up his nose as he spoke. "Did you see which way it went?"

Uh-oh. Rachel was alarmed when she

realized that the boys must have seen *Erin*, and mistaken her for a butterfly! Rachel's mind went blank with panic. What should she say to throw the boys off? "Um . . ." she began, thinking wildly. Then she realized that she could actually tell the truth. "I haven't seen a butterfly all day," she replied honestly. "We've been too busy birdwatching."

"Bird *chasing*, more like," Kirsty added. The boys nearly fell over laughing, clutching their stomachs.

Jason was laughing so hard he almost dropped his camera!

Rachel and Kirsty exchanged surprised glances. Kirsty's comment hadn't been *that* funny! "Giggles must be at it again," Rachel whispered to Kirsty. "But this time he's zapped too much humor into a joke!"

Just then, out of the corner
of her eye, Kirsty spotted
Erin waving at her from a
distance. Kirsty watched,
confused, as Erin threw a
ball of magic golden sparkles
up along the bank of the
stream, where it hovered in
midair. Kirsty smiled as she
realized what Erin was
trying to do. How
clever! "Hey, I can
see something golden
over there," she said to the
boys, pointing at the

shimmering ball of glitter. "Look!"

The boys stopped laughing and turned to see where Kirsty was pointing. Erin seemed to be working some magic that was making the ball flutter around so that, from a distance, it did look a lot like a butterfly. "Cool! Thanks, Kirsty," Tommy said. "Come on, Jason, let's go!"

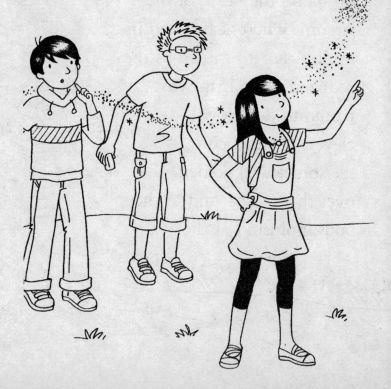

The boys raced off toward the magic golden sparkles, and Erin flew out from her hiding place. "Phew," she said. "That was a close one. Humans can *never* find out about the fairies, or our Fairyland home."

"Except for us," Rachel added.

Erin smiled. "Yes, except for the two of you, of course. But you help us all the time and we trust you. Other humans might not be as friendly."

The fairy gazed up to where Giggles had been perched in one of the trees. "Oh,"

she said in dismay. "Giggles flew away!
I didn't see him go—did either of you?"

Kirsty shook her head. "No," she said.
"I didn't dare look up at him with the

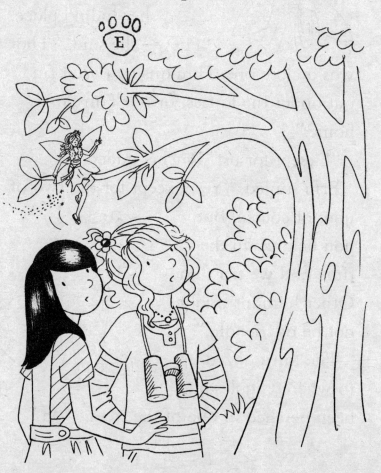

boys here. We wouldn't want them to see him." She stared around hopefully at all the treetops, but there was no sign of the phoenix's bright feathers. "Oh, no." She groaned. "Where could he be? We've got to find him again—and fast!"

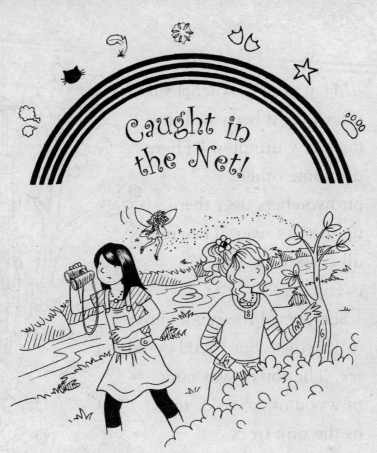

Caught in the Net!

The three friends headed out along the edge of the stream in search of Giggles. Rachel and Kirsty took turns with their binoculars, while Erin pulled out her own pair of tiny fairy binoculars to look through.

"Hey, look," Rachel said, after they'd been walking for a few minutes. "There are some other birdwatchers over there, up in the tower. They're all dressed up and everything!"

She passed the binoculars to Kirsty so her friend could see. The tower was built of wood and was as tall as the oak trees surrounding it. At the top of the tower was a viewing platform, where four birdwatchers stood. They were all dressed in camouflage clothes so they would

blend into the trees. The
birdwatchers also wore
wide-brimmed green hats,
and each had a pair of
fancy binoculars.
"Wow, they're taking it very
seriously," Kirsty commented.
"They even painted their faces
green, so they match the
leaves." She looked
up at them again and
noticed that one of the
birdwatchers was now
jumping up and down
excitedly, pointing at
something upstream. His
friends all turned and
looked—and then *they* began
to jump up and down, too!

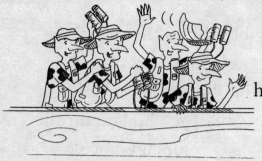

As one of them jumped extra high, his hat fell off. Kirsty gasped as she got a better look at his face.

"Rachel, Erin!" she cried, as she saw what a long green nose the hatless birdwatcher had. "They aren't birdwatchers with painted faces—they're goblins!"

Erin let out a little squeak of alarm. "Why are they so excited?" she wondered, turning her binoculars in the direction the goblins had been pointing.

Then she took a sharp gasp. "Oh—I know why!" she exclaimed. "They saw Giggles! He's perched on a log about

fifty feet from the viewing tower!"

"We have to get to him first," Rachel said. "Look—that goblin is carrying a net. We can't let them catch poor Giggles!"

"Come on," Kirsty said, and she and Rachel began running along the stream, with Erin flying above their heads. The goblins, meanwhile, were all pushing and shoving

each other in their rush to get down the steps of the wooden tower.

As the girls got closer, the goblins stomped down the last few steps and raced off. One had a net clasped in his hand.

"We won't be able to catch up with them on foot," Rachel panted. "Erin, can you turn us into fairies? We'll be able to go much faster if we can fly."

"Of course," Erin replied, quickly waving her wand over the girls. A stream of orange fairy dust floated out from her wand tip and swirled all around Kirsty and Rachel. As the magic 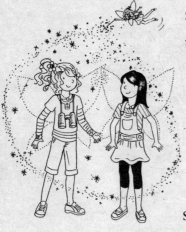 sparkles touched them, the girls felt themselves shrinking smaller and smaller . . . until they were the same size as Erin. Now they each had a pair of shimmery wings! With a few quick flutters, Rachel and Kirsty had zoomed up into the air to join their friend.

"After them!" Kirsty cried excitedly, flapping her wings as hard as she could. She, Erin, and Rachel all zoomed

through the air, being careful to fly
high so the goblins wouldn't notice
them.

*It's very hard to fly this fast through the
trees!* Rachel thought, swerving around
a pine tree so she didn't snag her wings
on its dark green needles. It was like a
fairy obstacle course! They were zipping
over and under branches, dodging the
tree trunks, and diving out of the way of
the birds and butterflies that were flying
through the woods.

Down below, the goblins were all
running at a great speed. There, farther
ahead, was Giggles, sitting on a log and
preening his long tail feathers.

"Watch out, Rachel!" Erin called
suddenly. Rachel quickly turned
her attention back to where she was

going—and saw that a robin was headed straight for her!

With a cry of alarm, Rachel swerved out of the way at the last second, and the robin passed by safely. Rachel's wings trembled with shock at the near-miss. If the robin's sharp beak had accidentally caught one of her wings, it would have been a disaster!

"Are you all right?" Kirsty called. She risked taking a glance at her friend as she kept flying.

Rachel nodded, but she was concentrating so hard on where she was flying that she didn't dare speak.

"We're almost there," Erin said.
"Giggles is just below us. Oh, no!"

Kirsty and Rachel glanced down,
wondering why Erin had cried out.
They looked just in time to see one
of the goblins throwing his net over
Giggles. The phoenix was trapped!

Joking Aside

Rachel was full of dismay. This was
awful! "Gotcha!" she heard one of the
mean goblins cheering from below.
She felt sick at the thought of beautiful
Giggles being caught by them.

"We need a plan," Kirsty said, flying
to perch on a nearby branch and
gesturing for the others to join her.
"At least the goblins don't know we're

here. If we're quick, we can think of some way to trick them and get Giggles back."

The three fairies stared down at the goblins, who were all congratulating each other on a job well done.

"Impressive work, partner," one of them said to the goblin with the net, slapping him on the back. "You were so quick—and so sneaky!"

The goblins were giving each other high-fives and looked really pleased with themselves. "Jack Frost is going to be so happy," one said. "He might even smile—imagine that!"

The mention of smiling reminded Rachel of earlier, when she and Kirsty had been smiling and giggling at jokes. Then she remembered how they'd been helpless with laughter at one point . . . and an idea popped into her head.

"I've got it," she said to Erin and Kirsty, her eyes shining. "What if we can make the goblins laugh—I mean,

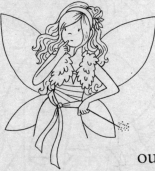

really laugh, like we were laughing, Kirsty? With Giggles nearby to strengthen their senses of humor, we can tell them some jokes. Hopefully they'll all be rolling with laughter in no time. And then, with some luck, we'll be able to rescue Giggles from the net."

"I love it!" Kirsty exclaimed. "Great idea, Rachel!"

Erin didn't look quite so sure. "It's a good idea, but we'll have to hope that Giggles' magic is working," she said. "You saw what happened earlier, when he zapped the humor out of my joke—you two didn't even smile! If the same thing happens again, any joke you tell the

goblins will fall flat, and they won't laugh. Even worse, they'll be really suspicious of you."

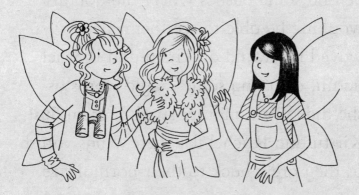

"I see what you mean," Rachel said, "but I still think we should try. I can't think of any other ideas to help Giggles escape—can you?"

Kirsty shook her head.

"It's definitely worth a try," Erin said. "Let's fly down lower, behind those bushes, and I'll turn you back into girls.

Then we'll just have to cross our fingers and hope that Giggles can pull it off!"

The three fairies fluttered down behind some bushes where the goblins wouldn't be able to see them. Erin waved her wand at Kirsty and Rachel again, chanting some magic words as she did. With another swirl of fairy dust, Kirsty and Rachel felt their wings vanish as they grew back to their normal size.

The two girls came out from behind the bushes and approached the goblins. The goblins didn't look at all happy to see them. One of them held

up a warning hand.
"Stop there," he said.
"Keep your distance.
We've got the phoenix,
and there's nothing
you can do about it
now."

Rachel shrugged as
if she wasn't really
interested. "Oh, right," she said coolly.
"Actually, we just came over to tell you
a funny joke. We thought you might like
a laugh after all your hard work." She
could see that the goblins were about
to disagree, so she just went ahead with
it. "What does Jack Frost like to eat for
breakfast?"

The goblins looked at each other and
shrugged. "I don't know," one replied.

"Frosted flakes!" Rachel cried,
grinning.

Kirsty watched the goblins' faces
eagerly, hoping they would find Rachel's
joke funny. Unfortunately, they didn't
even smile.

"I don't get it," one of the goblins
muttered, looking confused.

"Jack Frost doesn't even eat breakfast," another said scornfully.

Kirsty and Rachel exchanged worried glances. Oh, dear. Giggles' magic wasn't working very well at all. They had to make the goblins fall over laughing if they were going to have a chance of rescuing the phoenix—but at this rate, that was never going to happen!

Go, Go, Giggles

Kirsty tried next. "How about this one: what do you get if you cross Jack Frost with a vampire?" she asked. "Frost bite!"

This time, the goblins smiled. One of them even chuckled. "Frost bite, I like that," he said.

Feeling encouraged, Rachel gave
them another one. "How does Jack Frost
travel to work?" she asked. "By icicle!"
Yes! The goblins all burst out
laughing. "Not bicycle—icicle!" one of
them giggled, shaking with laughter.

Kirsty grinned at Rachel. The plan
was working! "What did Jack Frost say
to Frosty the Snowman?" she asked
them. "Have an *ice* day!"

"'Have an ice day!'" one of the goblins repeated, clutching his stomach and cracking up.

"How do you keep a goblin in suspense?" Rachel asked them next.

"We don't know," the goblins spluttered in reply.

"We'll tell you tomorrow!" Rachel and Kirsty chorused.

At this, the goblins all fell over with
laughter. They were rolling around on
the ground, shoulders shaking, tears
of glee streaming down their cheeks.
"I get it!" one chuckled. "We're goblins,
and they're keeping us in suspense!"

"Hilarious!" Another gasped,
thumping the ground as he laughed.

Kirsty and Rachel looked at each

other, then at the goblins' net. It was on the ground, with Giggles trapped inside. The goblins were still helpless with laughter.

"Now!" Kirsty declared.

Without any hesitation, the girls ran to the net and lifted it up. Erin flew over to them, her arms outstretched. "Giggles! I'm here!" she called. Giggles blinked, shook out his feathers, and gave a happy laugh as

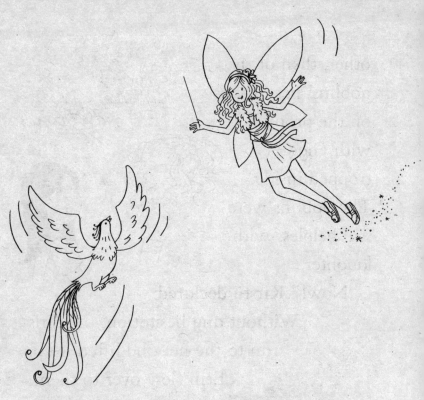

he saw his fairy friend. He flapped his
shimmering wings and flew out of the
net toward Erin. He shrank down to
fairy-size as he went.

Giggles looked so sweet as he flew
into Erin's arms. He nestled his head on
her shoulder and let out trills of melodic

laughter. "Hello,
sweetie," Erin
said, stroking
him gently. Then
she laughed, too.
"Oh, it's so good
to have you back
again!"

The goblins,
meanwhile, were still rolling
with laughter, and Giggles let out an
amused chirp as the tears ran down
their green cheeks. "We'd better get out
of here," Erin said to Kirsty and Rachel
in a low voice. "Once they realize they
don't have the phoenix anymore, they'll
have to go back to Fairyland and tell
Jack Frost. Unfortunately, they won't
find that quite as funny."

"Good-bye, Erin. Good-bye, Giggles," Rachel said, patting the little bird's soft feathers. "Thanks for all the laughs."

"Yes, that was the funniest adventure we've had in a long time!" Kirsty smiled. "Good-bye!"

Erin waved and grinned as she and Giggles flew off in a shower of sparkles. Rachel and Kirsty watched until the last magical sparkle had vanished, then turned to each other.

"We'd better go
back to camp,"
Kirsty said.
"I'm so glad
we helped Erin
find Giggles, but
it's too bad we
weren't able to
find all the birds
on our list."

The two girls took a few steps away
from the goblins. Then Rachel froze,
clutching Kirsty's arm. "*Chickadee, dee,
dee*" they heard.

Kirsty grinned as she spotted a small

white and black bird on the branch of a nearby tree. "A chickadee!" she whispered, fumbling to turn on the camera. She held it out and pressed the button. *Click!*

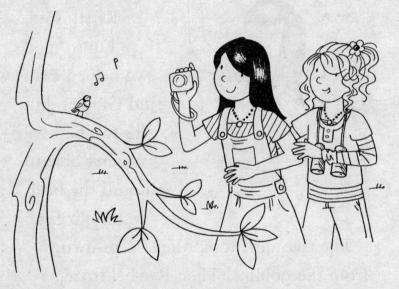

She and Rachel watched the little chickadee as it hopped along the branch, then fluttered away. "We did it!" Rachel cheered, checking it off her list.

"Hooray! I can't wait to tell everyone about the birds we saw."

Kirsty grinned and slipped an arm through Rachel's as they headed back toward camp. "Me, too," she said with a wink. "But we won't tell them about *all* the birds we saw!"

THE MAGICAL ANIMAL FAIRIES

Erin the Phoenix Fairy has taken
her magical animal back to Fairyland!
Now Rachel and Kirsty need to help . . .

Rihanna

the Seahorse Fairy!

Join their next adventure
in this special sneak peek. . . .

Adventure Lake

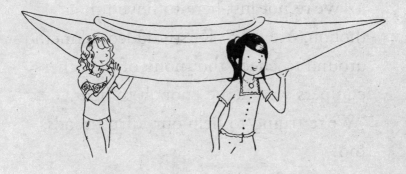

"Oh, I'm really looking forward to going canoeing again!" Kirsty Tate said eagerly to her best friend, Rachel Walker. The girls were carrying a lightweight canoe on their shoulders as they walked through the camp toward Adventure Lake. "But I'm going to try

to keep my feet dry this time!"

Rachel laughed. "Yes, it's a lot of fun, isn't it?" she agreed. "I'm glad we have some free time this afternoon so that we can have another try."

"We're not just here to have fun though, are we?" Kirsty added, glancing around to check that none of the other campers were close enough to hear. "We're trying to help our fairy friends, too!"

On the day the girls arrived at the adventure camp, the king and queen of Fairyland had asked for their help to find seven missing magical animals. These special young animals had amazing powers that helped to spread the kind of magic that humans and fairies could possess—the wonderful

gifts of imagination, good luck, humor, friendship, compassion, healing, and courage.

The seven Magical Animal Fairies spent a whole year training the magic youngsters before the animals returned to their families in Fairyland. At that time, they were ready to use their special talents to help everyone in both the human and the fairy worlds. However, spiteful Jack Frost was determined to put a stop to all this, simply because he wanted everyone to be as lonely and miserable as he was.

So he and his naughty goblins had kidnapped the magical animals and taken them to his Ice Castle. But the animals had managed to escape, and now they were hiding in the

human world. Rachel and Kirsty were determined to find all seven magical animals before Jack Frost and his goblins did, and then the girls planned to return them safely to Fairyland.

"We've done pretty well so far, haven't we, Kirsty?" Rachel remarked. "We've found Ashley's dragon, Lara's black cat and Erin's phoenix."

Kirsty nodded. "I just hope we find the others before the end of the week—" she began. But just then Lila, one of the camp counselors, came out of a nearby tent, and Kirsty and Rachel exchanged a warning glance. Both girls knew that *no one* in the human world could ever find out about the existence of fairies. . . .

RAINBOW magic™

There's Magic in Every Series!

The Rainbow Fairies

The Weather Fairies

The Jewel Fairies

The Pet Fairies

The Fun Day Fairies

The Petal Fairies

The Dance Fairies

The Music Fairies

The Sports Fairies

The Party Fairies

The Ocean Fairies

The Night Fairies

The Magical Animal Fairies

Read them all!

www.scholastic.com
www.rainbowmagiconline.com

HIT entertainment

RMFAIRY5